Drift

Philippe Parreno

PENGUIN BOOKS

PENGUIN BOOKS

Published by the Penguin Group
Penguin Books Ltd, 80 Strand, London WC2R ORL, England
Penguin Group (USA) Inc., 375 Hudson Street, New York, New York 10014, USA
Penguin Group (Canada), 90 Eglinton Avenue East, Suite 700, Toronto, Ontario, Canada
M4P 2Y3 (a division of Pearson Penguin Canada Inc.)
Penguin Ireland, 25 St Stephen's Green, Dublin 2, Ireland (a division of Penguin Books Ltd)
Penguin Group (Australia), 250 Camberwell Road, Camberwell, Victoria 3124, Australia
(a division of Pearson Australia Group Pty Ltd)
Penguin Books India Pvt Ltd, 11 Community Centre, Panchsheel Park, New Delhi – 110 017,
India Penguin Group (NZ), 67 Apollo Drive, Rosedale, Auckland 0632, New Zealand
(a division of Pearson New Zealand Ltd)
Penguin Books (South Africa) (Pty) Ltd, Block D, Rosebank Office Park, 181 Jan Smuts Avenue,
Parktown North, Gauteng 2193, South Africa

Penguin Books Ltd, Registered Offices: 80 Strand, London WC2R ORL, England

www.penguin.com

First published in Penguin Books 2013
001

ISBN: 978-1-846-14629-9

www.greenpenguin.co.uk

ALWAYS LEARNING PEARSON

DRiFT

(DERiVE)

PARRENO

FOR

PENGUIN

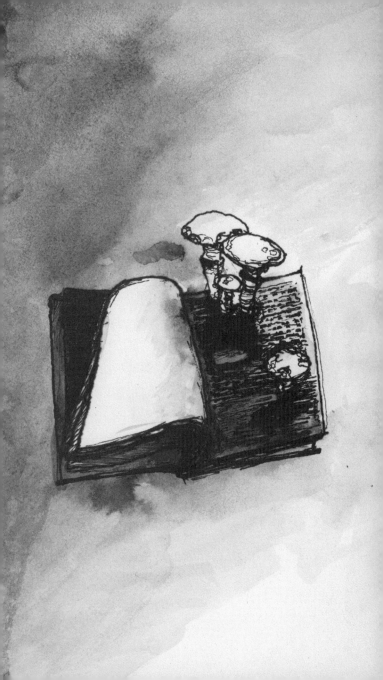

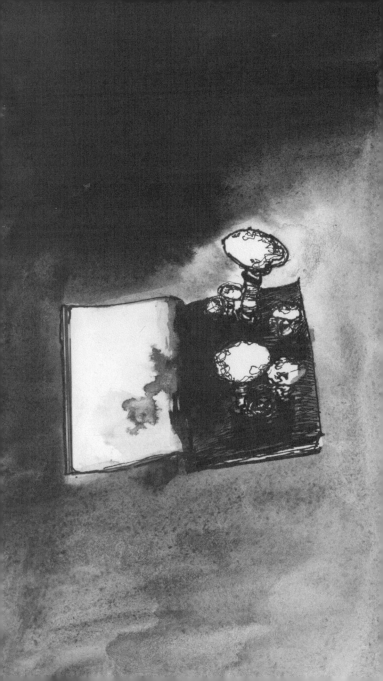

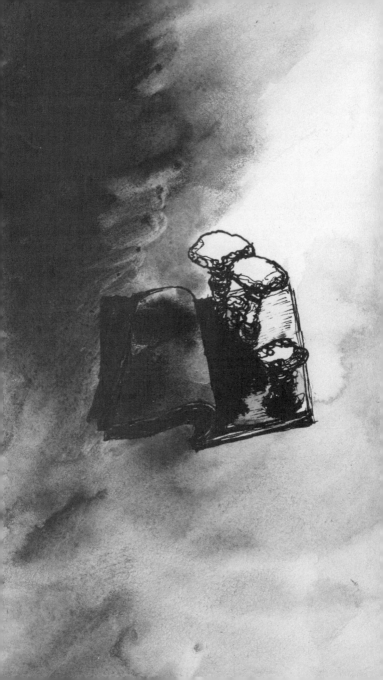

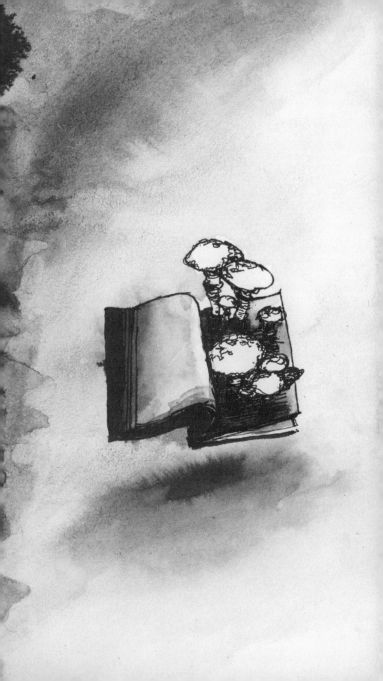

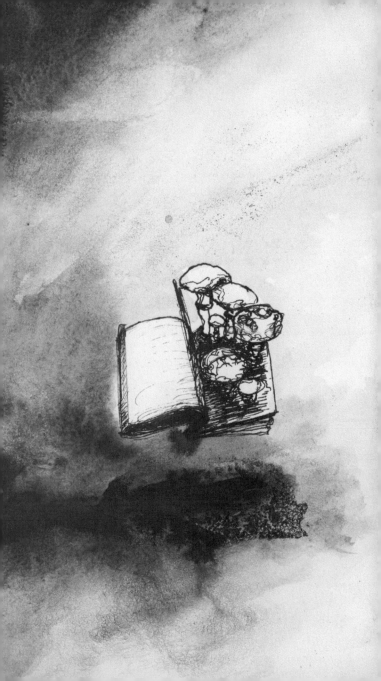

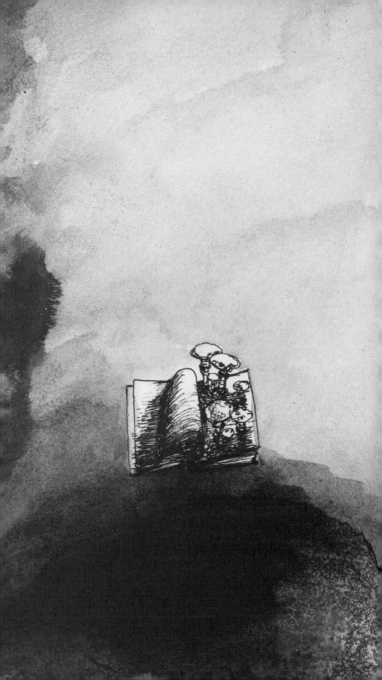

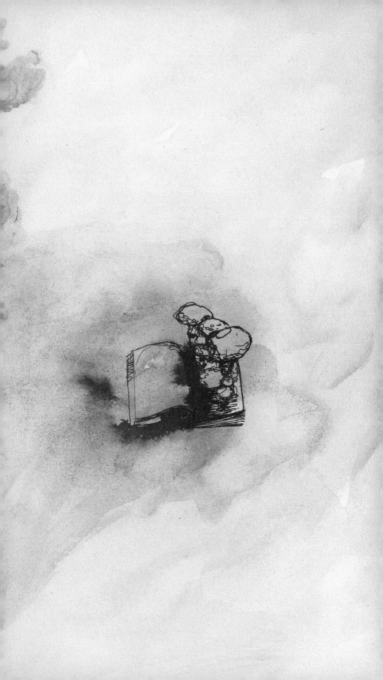

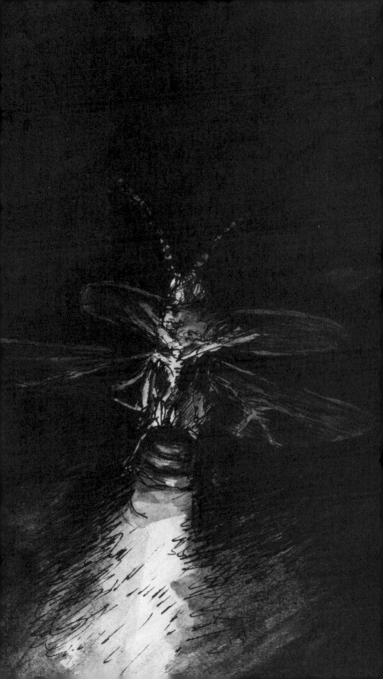

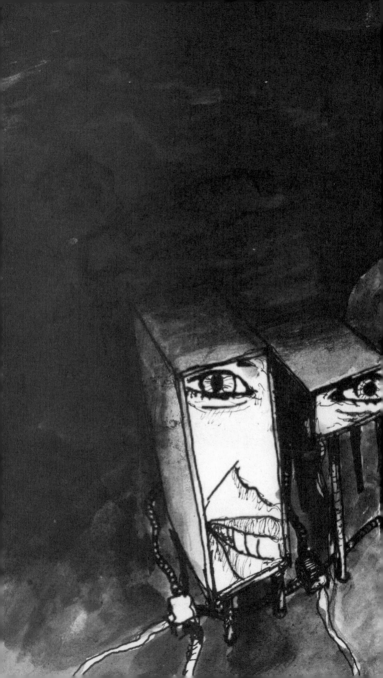

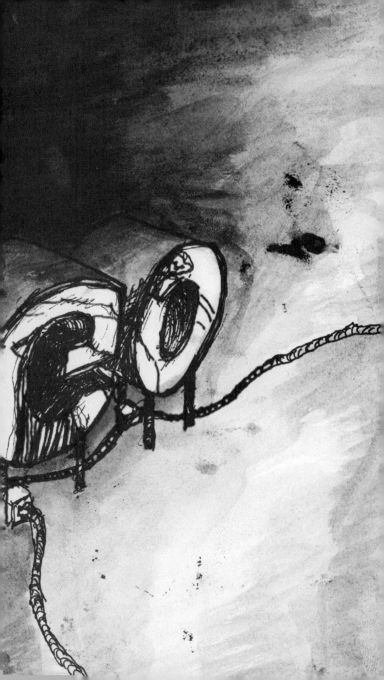

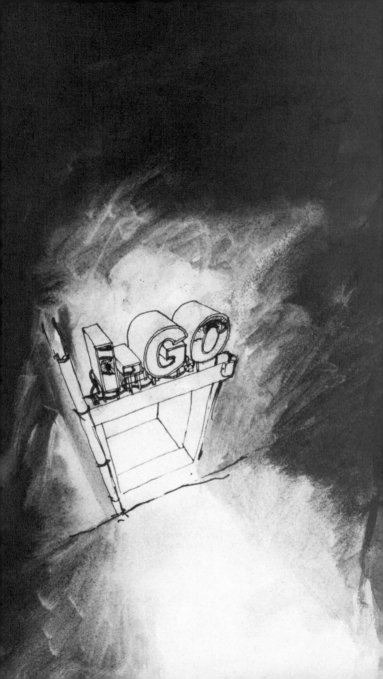

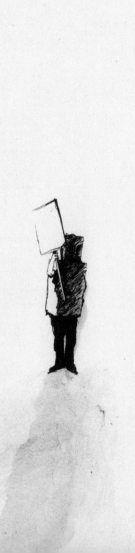

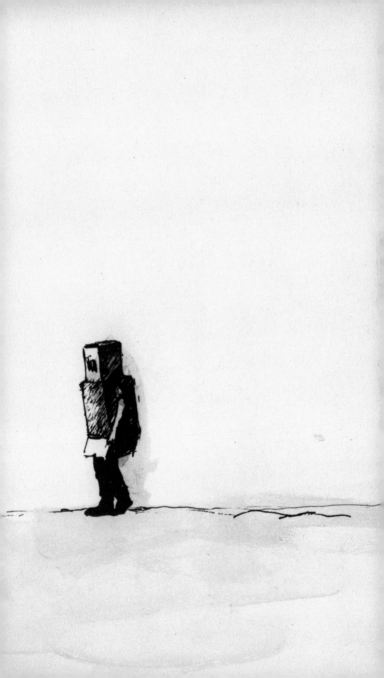

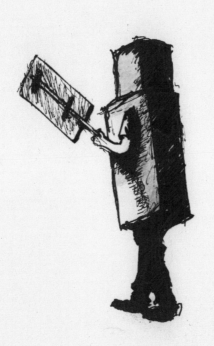

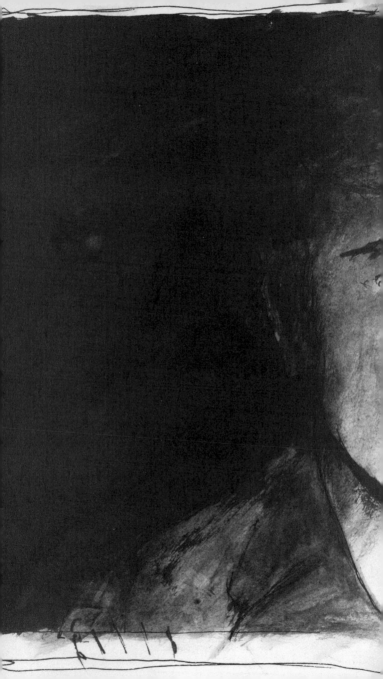

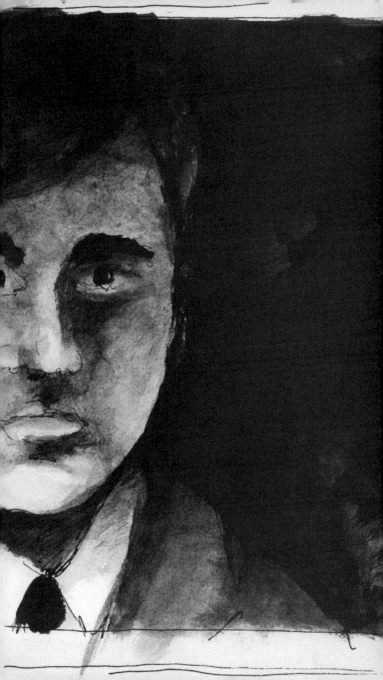

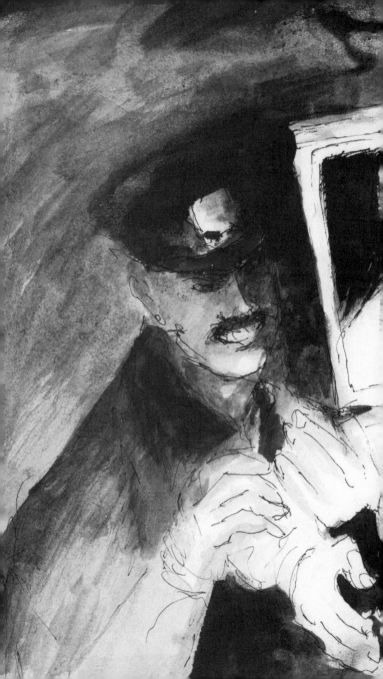

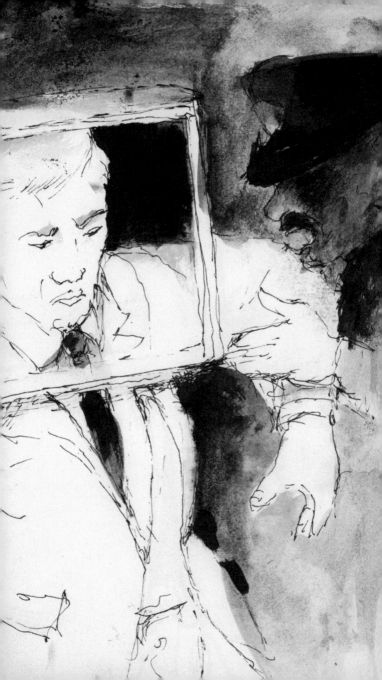

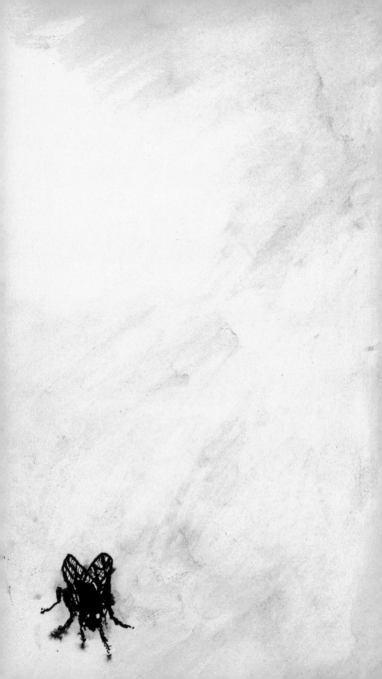

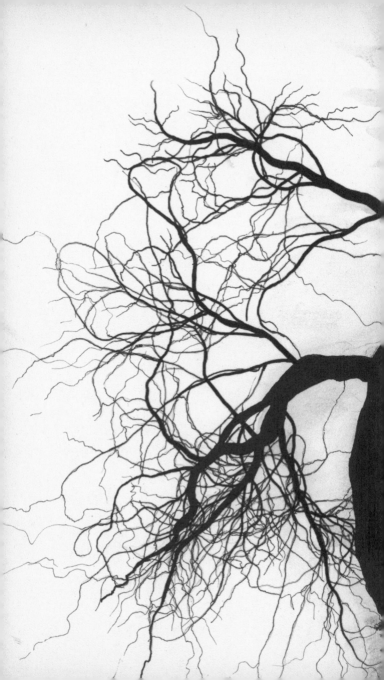

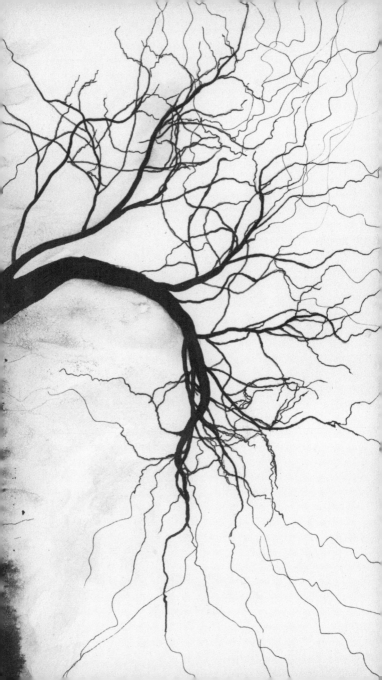

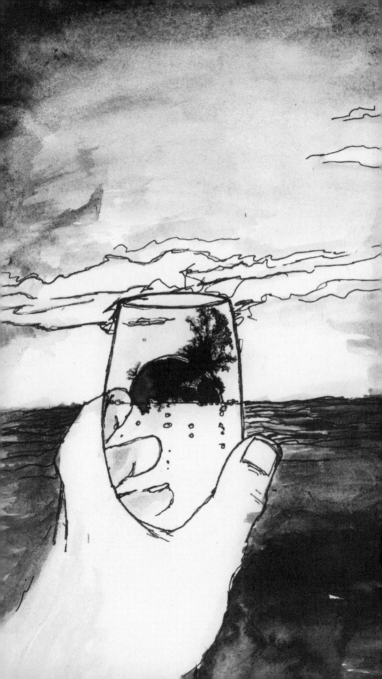

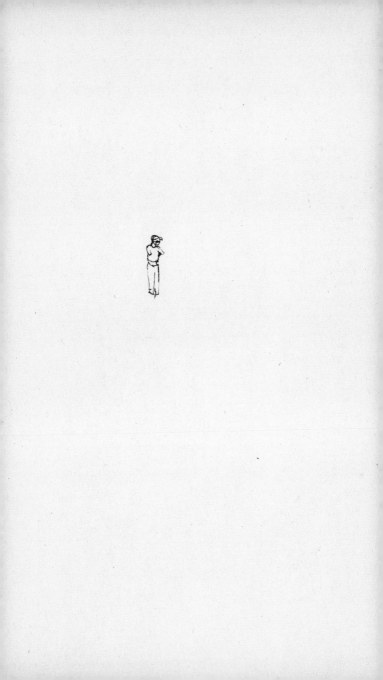

PENGUIN LINES

Choose Your Journey

If you're looking for...

Romantic Encounters

Heads and Straights
by Lucy Wadham
(the Circle line)

Waterloo–City, City–Waterloo
by Leanne Shapton
(the Waterloo & City line)

Tales of Growing Up and Moving On

Heads and Straights
by Lucy Wadham
(the Circle line)

A Good Parcel of English Soil
by Richard Mabey
(the Metropolitan line)

Mind the Child
by Camila Batmanghelidjh and
Kids Company
(the Victoria line)

The 32 Stops
by Danny Dorling
(the Central line)

*A History of Capitalism
According to the Jubilee Line*
by John O'Farrell
(the Jubilee line)

A Northern Line Minute
by William Leith
(the Northern line)

**Laughter and
Tears**

Mind the Child
by Camila Batmanghelidjh and
Kids Company
(the Victoria line)

Heads and Straights
by Lucy Wadham
(the Circle line)

**Breaking
Boundaries**

Drift
by Philippe Parreno
(the Hammersmith & City line)

Buttoned-Up
by Fantastic Man
(the East London line)

Waterloo–City, City–Waterloo
by Leanne Shapton
(the Waterloo & City line)

Earthbound
by Paul Morley
(the Bakerloo line)

Tube Knowledge

The Blue Riband
by Peter York
(the Piccadilly line)

*What We Talk About When
We Talk About The Tube*
by John Lanchester
(the District line)

*A Good Parcel of
English Soil*
by Richard Mabey
(the Metropolitan line)

A Breath of Fresh Air

*A Good Parcel of
English Soil*
by Richard Mabey
(the Metropolitan line)

Design for Life

Waterloo–City, City–Waterloo
by Leanne Shapton
(the Waterloo & City line)

Buttoned-Up
by Fantastic Man
(the East London line)

Drift
by Philippe Parreno
(the Hammersmith & City line)